PHOTO RESPIRATION

TOKIHIRO SATO PHOTOGRAPHS

ELIZABETH SIEGEL

THE ART INSTITUTE OF CHICAGO

Photo-Respiration: Tokihiro Sato Photographs has been published in conjunction with an exhibition of the same title presented at the Art Institute of Chicago from January 15 to May 8, 2005.

This exhibition is organized by the Art Institute of Chicago and made possible by the Black Dog Fund.

First edition
Printed in the United States of America

Published by the Art Institute of Chicago, 111 South Michigan Avenue, Chicago, Illinois 60603–6110

Distributed worldwide by
D.A.P. / Distributed Art Publishers, Inc.
155 Sixth Avenue, 2nd Floor
New York, New York 10013–1507
212-627-1999; 212-627-9484 (fax)

Library of Congress Control Number: 2004117001

ISBN 0-86559-217-9

Produced by the Publications Department of the Art Institute of Chicago, Susan F. Rossen, Executive Director
Edited by Elizabeth Stepina
Production by Amanda W. Freymann, Associate Director Publications-Production
Designed and typeset by Nicole Eckenrode, Department of Graphic Design and Communication Services
Separations by Professional Graphics, Rockford, Illinois
Printing and binding by Original Smith Printing, Bloomington, Illinois

Front cover: *#330 Taiji* (detail), 1998 (plate 11)

ACKNOWLEDGMENTS

First of all, I would like to express my sincere gratitude and admiration to Tokihiro Sato, whose beautiful photographs have rekindled my sense of wonder for photography. Special thanks are also due to Leslie Tonkonow and all the staff at Leslie Tonkonow Artworks + Projects, who have gone above and beyond—with passion and creativity—to ensure that this installation happened. In Japan, Akira Ishino and Maki Kitamura of Gallery Gan, Tokyo, provided additional important support.

The exhibition is made possible by the Black Dog Fund. I want to thank Judy and Scott McCue for their confidence in the project. Sato's travel to Chicago is underwritten by American Airlines, and the Japan America Society of Chicago assisted in making his presence here a reality. I am also very grateful to the lenders to the exhibition for their generosity in allowing us to show Sato's photographs for an extended period of time.

At the Art Institute, numerous people played important roles in the exhibition and catalogue. James Cuno, our recently arrived Director and an avid photography fan, supported the project from the start, as did Dorothy Schroeder, Associate Director for Exhibitions and Budgets. In the Department of Photography,

David Travis, Curator and Department Head, gave consistently wise counsel. Assistant Curator Katherine Bussard generously lent her expertise and enthusiasm to several drafts of the essay. Jim Iska and Doug Severson demonstrated constant good cheer and innovation in preparing a complicated installation, and Lisa D'Acquisto and Leslie Wakeford helped with the countless details that proved to be all too important. Debra Purden of Museum Registration coordinated the loans to the exhibition with her usual competence.

Through sheer persistence and imagination, Susan Rossen and Amanda Freymann of the Department of Publications made sure that this catalogue came into existence. Elizabeth Stepina gave the text clarity, and Nicole Eckenrode created the clean, elegant look the photographs deserve. John Bukacek provided a fine translation, on very short notice, for Sato's words. Finally, I would like to thank Janice Katz, Assistant Curator of Japanese Art, for her many enlightening conversations about the Japanese context for Sato's work.

ELIZABETH SIEGEL
Assistant Curator of Photography

DRAWING WITH LIGHT

TOKIHIRO SATO'S PHOTOGRAPHS

ELIZABETH SIEGEL

WHEN YOU FIRST ENCOUNTER one of Tokihiro Sato's photographs, you see an ethereal landscape that is absent of people but populated by bright spots or lines of light. When you view one of his suspended, illuminated transparencies, you also notice that the lights *behind* the picture permeate the light spots *in* the picture. The photographs are immediately entrancing, but they are also slightly confusing: just how, you wonder, were they made? Once you learn that Sato keeps the camera's shutter open for an hour or more, travels throughout the landscape in the field of view, and marks his path with flashlights or mirrors, you realize there is much more to these images than lovely light effects. The work begins to connote the passage of time, a performance, and the artist's own body in space. Sato's technique also addresses something particular to the medium of still photography: its peculiar inability to record objects in motion over an extended length of time.

When Louis-Jacques-Mandé Daguerre announced the invention of photography in January 1839, the astonished public immediately understood that the technique could do something that no other process had ever done before: preserve remarkably accurate and faithful pictures of the world. To the amazement of viewers, it seemed as if the sun itself printed images—of boulevards and bridges, specimens and sculptures—with intricate detail. Magical as the new technology appeared, however, it had some limitations. *La Gazette de France* reported that, among other shortcomings, it could not record moving objects: "Nature in motion cannot reproduce herself, or at least can do so only with great difficulty, by the technique in question."[1] In one daguerreotype of a boulevard view, for example, a bustling street seemed deserted, and a horse that had stirred appeared headless. Due to the lengthy exposure time required to capture an image, anything that moved was rendered invisible.

Tokihiro Sato has turned photography's early deficiency to his advantage. The artist remains unseen in his long-exposure photographs, although his movement in front of the camera is documented by the light he uses to record his trail. The results, like Daguerre's early experiments, are also wondrous. By capitalizing on still photography's unique relationship to the depiction of motion, and by using the essential component of light as a key element (both in the making and presentation of his images), Sato creates pictures that actively engage the particular history and process of the photographic medium.

Born in Japan in 1957, Tokihiro Sato attended Tokyo National University of Fine Arts and Music with the full intention of becoming a sculptor. He worked in steel and iron, hammering and welding metal into forms that directed flows of water and light. For Sato the physical process of creation was more important than the resulting object; the act of rhythmically and repetitively pounding material not only shaped it, but also linked the duration of his action with the expressive form of the work. Still, after completing undergraduate and graduate courses in sculpture, he found himself dissatisfied with what he perceived as the medium's inability to convey a sense of life. As a student, Sato had learned how to use a large-format camera to document his work, and in 1987 he began incorporating photography into his sculpture. His early experiments are long-exposure photographs in which he used a small flashlight to draw lines of light around his sculptures, reflecting their form and the motions that created them. The combination of the light, the element of time, and the evidence of his exertions thrilled him; the resulting images fulfilled his craving for a concrete expression of living, breathing existence. He began to work increasingly in photography, ultimately pushing his first, tentative "light-drawings" into an ongoing series that moved beyond single pieces of sculpture to the expanse of nature.

Sato's technique in these pictures is marvelously simple: Working with an 8 x 10-inch camera placed on a tripod, he makes exposures that last from one to three hours. After he chooses his site and establishes his framed area, he then traverses the landscape, delineating his journey by "drawing" with light while the film is exposed. At night he uses a single flashlight powered by a battery-pack to trace lines in the space. At times the lines of light hover vertically, as above a staircase (plate 1), while at others he forms complicated patterns of swirls (plate 4). During the day, Sato places a darkening filter on his lens (to prevent overexposure) and uses a mirror to periodically reflect sunlight back at the camera. He aims the mirror at a reflective frame mounted around the camera, so he can see whether the light is directed correctly. He then holds the mirror in place for about ten seconds, and walks (or, in some cases, swims) to the next spot, concealing the mirror as he moves. In both of these methods, Sato works quite deliberately and systematically, keeping track of where he and his lights have been. The long exposures capture only the lines or dots of light that trace the artist's path through the space, and Sato himself remains unseen. In fact, anything that moves during the exposure is rendered invisible: waves crashing against rocks become mist; a crowded Tokyo intersection appears unpopulated. In snowy land-scapes, he starts from the very back of the scene and works his way forward, so that the image of the unbroken snow in front is exposed to the film and his footprints seem to vanish.

Sato chooses his sites intuitively; he is drawn to "places that seem to emit tiny sparks, that give off the air of an age."[2] Several of his flashlight images, such as *#278 Koto-ku Aomi* (plate 3), were created at the future site of the Tokyo Waterfront Subcenter, a place that was allowed to grow wild and overrun. There he sensed "certain equilibriums, or negative spaces, among the architecture which appear to me as air pockets. This is what I think of as sculptural space."[3] As in his early experiments with sculptural forms, these pictures reveal a relationship between matter and energy, stillness and movement, and

actual forms and potential ones. Sato's selection of locations encompasses bustling downtown inter-sections, tranquil forests, and rocky coasts (the sea never being far away in Japan). In several of his seascapes, even the coastline is sculptural; the geometrically shaped concrete blocks that contrast so elegantly with the round spots of light and the smooth waves are there to prevent erosion (plate 9).

Sato defines himself neither as a sculptor nor a photographer, since the limitations he perceives in either term do not leave room for his fusion of the two media. Although a photograph is always a translation of a three-dimensional space into a two-dimensional image, Sato purposefully emphasizes this discrepancy, which he calls "the gap in perspective." The physical nature of his activity throughout the landscape—running, swimming, breathing, sweating—is tremendously important to him; his corpo-real presence, over time and space, is central to the making and understanding of the picture. To create *#330 Taiji* (plate 11), for example, Sato had to scramble over volcanic rocks, wading and swimming among the waves that buffeted his body (often making it difficult to aim the mirror correctly), in order to cover a fair amount of space in the prescribed time of the exposure. The artist welcomes this labor, and refers to this ongoing series as "photo-respiration," or "breath-graphs," because of the human experience that the pictures record.

It is not surprising that Sato treats light itself as a material substance. When installing his work, he underscores the importance of light by suspending his images as large transparencies a few inches in front of light panels. In this glowing display, illuminated from behind, traces of the artist's presence connect with the light of the presentation. Sato is interested in the photographic object as much as the photographic image, and this installation links sculpture and photograph. He pays particular attention to the paper, allowing the edges and even the back of the print to become visible.

"When I show my work," he says, "I wish to show that even though the paper is thin, it is a substance that possesses a thickness perceived as thinness" (see interview, p. 30). Although process is as paramount as it was in his early sculptures, Sato finds more importance in the objects resulting from his photographic works; ironically, it is his pictures, not his sculpture, that have freed him to concretize his ideas. His current projects continue to further engage the three-dimensional possibilities of light and photography; he has recently utilized a camera obscura as an interactive object of public sculpture.

Although Sato lists his artistic influences as including both conceptual and land art, scholars writing on his work have also recognized qualities that are particular to a traditional Japanese aesthetic. While Sato himself does not emphasize this connection, his unpopulated scenes easily lend themselves to a timeless interpretation. Several of his images—those set in the forest or the sea, for example—seem to possess an ancient quality that hearkens back to traditional representations of the Japanese landscape. His distinctive compression of events over time, depicted within a single frame, recalls narrative handscrolls in which the same character is often repeated within a composition in order to advance a story.[4] The invisibility of the central human figure—in this case, the artist himself—has been interpreted as an indication of the anomie of modern Japanese society, or, in traditional aesthetic terms, as the subsuming of the self to truly identify with the subject matter depicted.[5] And the presence of floating orbs of light, like ghosts hovering above the ocean or among the busy pedestrians, seems to imply the existence of a spirit world, a belief that extends far back in Japanese religious history.[6] Rejecting the strain of colorful, narrative pop images that characterize much of Japanese photography of the 1980s and 1990s, Sato instead is among a select group of photographers concerned with the place of the Japanese within their own landscape.[7]

Although Sato's photographs record his performance through space and time, they provide more than mere documentation. Whereas instantaneous, or stop-action, photography analyzes a moment, Sato's photographs synthesize a series of moments. They unite a performative act and sculptural space with a uniquely photographic depiction. The lights in the photographs serve as markers of the passage of time and the journey through space, all compressed into a single frame that we experience simultaneously. This synthesis translates as magical: bodies disappear, sparkling lights hover, and an hour is perceived in a second. Yet there is no trickery here; just the special capabilities and limitations—the simple magic— of photography.

1. H. Gaucheraud, "The Fine Arts: A New Discovery," *La Gazette de France* (Paris), Jan. 6, 1839, trans. Beaumont Newhall, repr. in *Photography: Essays and Images*, ed. Beaumont Newhall (New York: Museum of Modern Art, 1980), p. 17.

2. Tokihiro Sato, "Photo-Respiration; Notes from July 1996," in *Sato Tokihiro: Photo-Respiration* (Tokyo: Gallery Gan, 1996), p. 11.

3. Ibid.

4. See Robert T. Singer, "Japan's Persisting Traditions: A Premodern Context for Postmodern Art," in Robert Stearns et al., *Photography and Beyond in Japan: Space, Time and Memory* (Tokyo: Hara Museum of Contemporary Art, 1995), pp. 223–27.

5. Ibid.

6. See, for example, H. S. K. Yamaguchi and Atsuharu Sakai, *We Japanese: Being Descriptions of Many of the Customs, Manners, Ceremonies, Festivals, Arts and Crafts of the Japanese besides Numerous other Subjects* (Hakone: Fujiya Hotel, Ltd., 1950), whose preface states, "The Japanese believe in Kami (lit. unseen) and most of their life, daily and national, is influenced by their fear of the Unseen."

7. Robert J. Fouser, "In Praise of Mad Shadows: The Photography of Tokihiro Sato," *Art AsiaPacific* 21 (1999), p. 46. Fouser notes that the contrast between Sato's work and that of contemporary artists such as Nobuyoshi Araki and Yasumasa Morimura "represents a return to the division between 'high' contemplative arts and 'low' ribald arts in Japanese culture."

PLATES

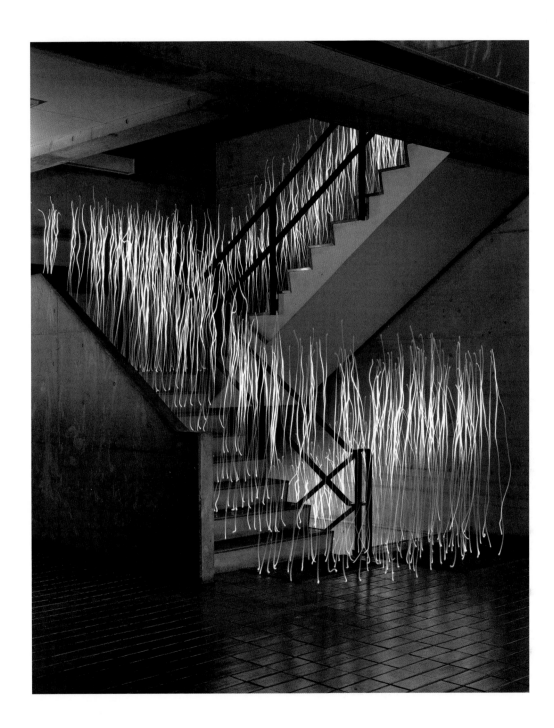

1

#22

1988

2

#370 Saitamakinbi

1999

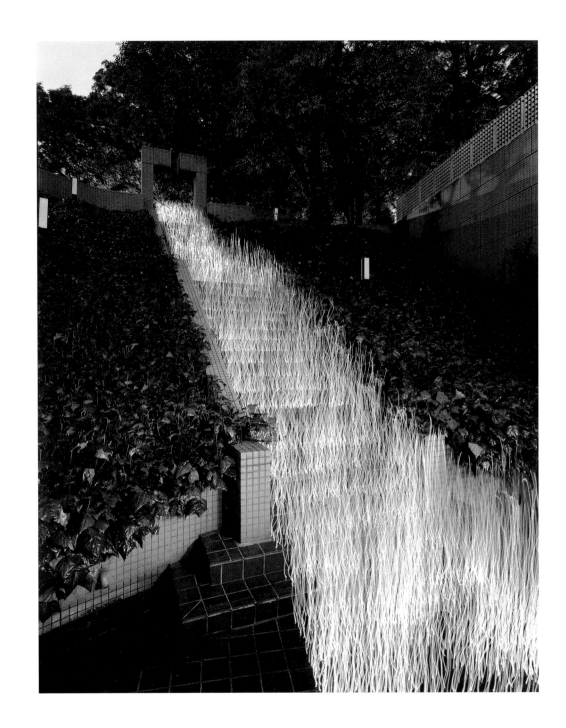

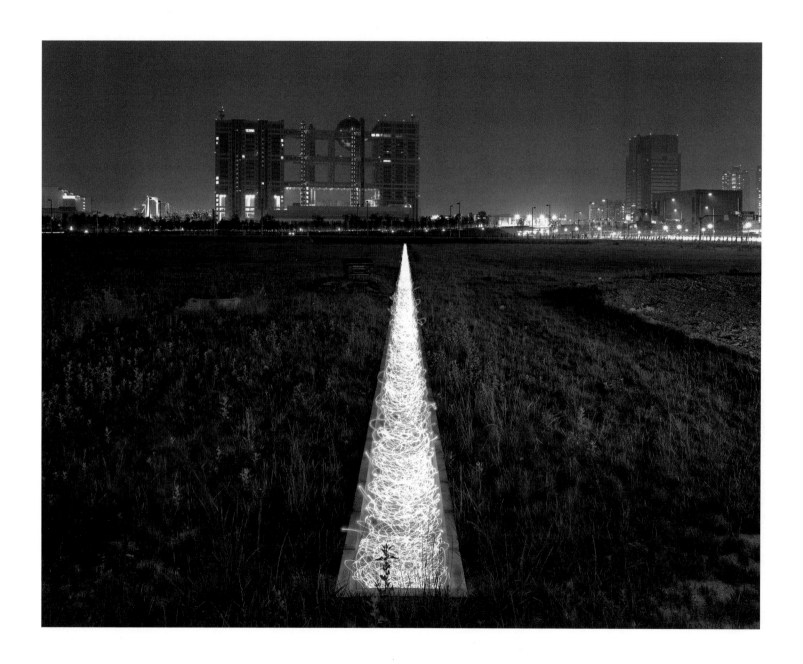

3

#278 Koto-ku Aomi

1996

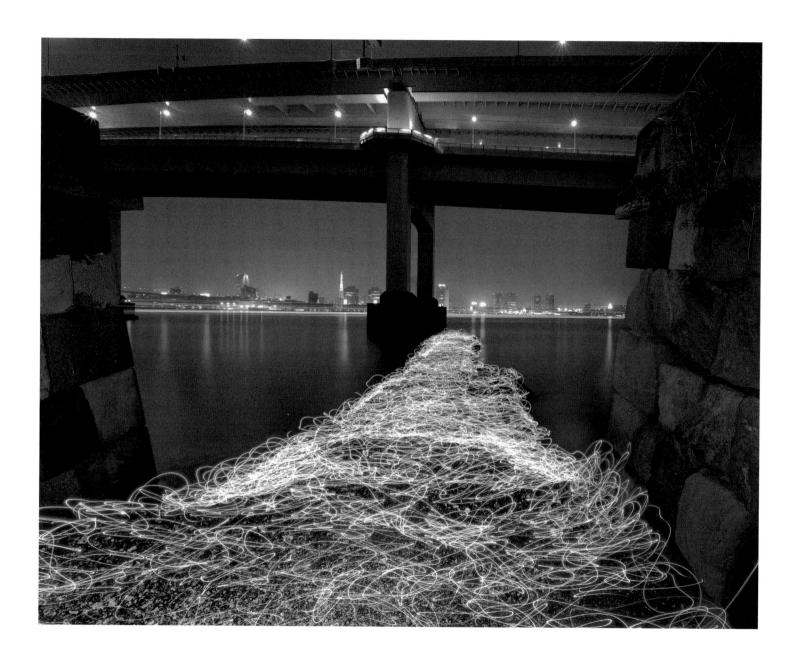

4

#267 Minato-ku Daiba

1996

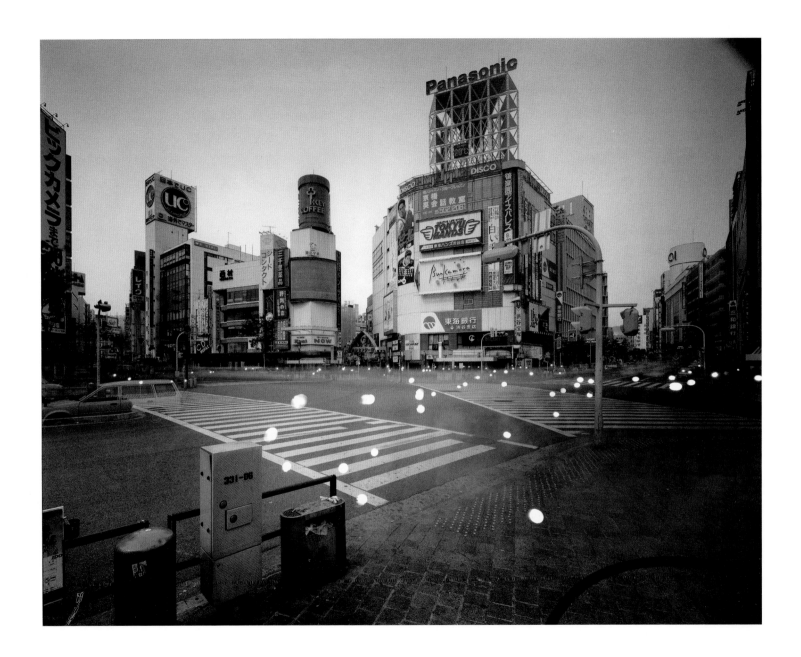

5

#87 Shibuya

1990

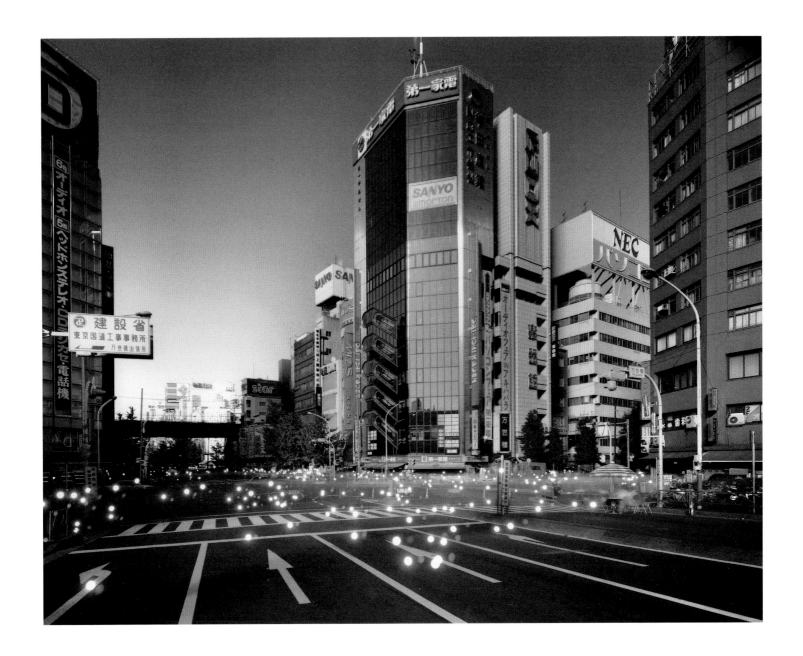

6

#166 Akihabara

1992

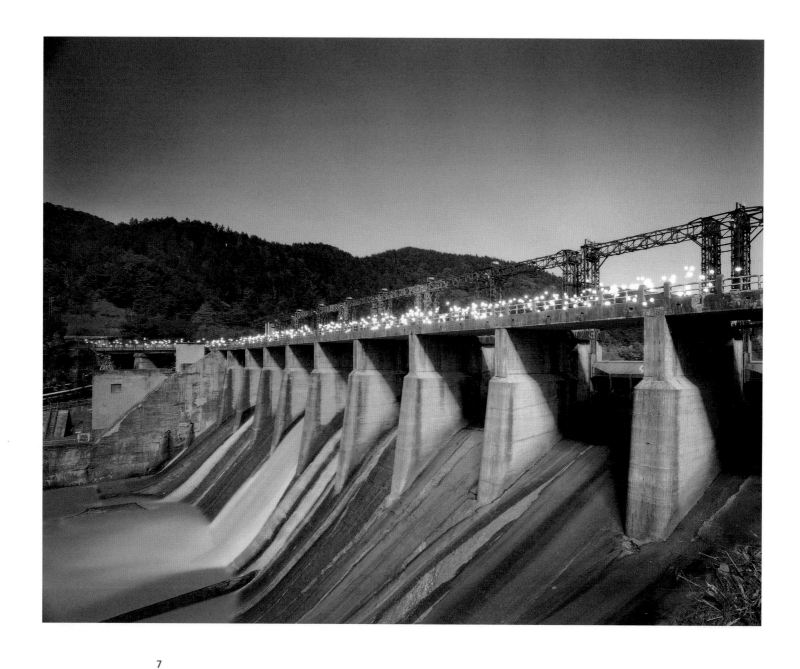

7

#161 Shimizusawa

1992

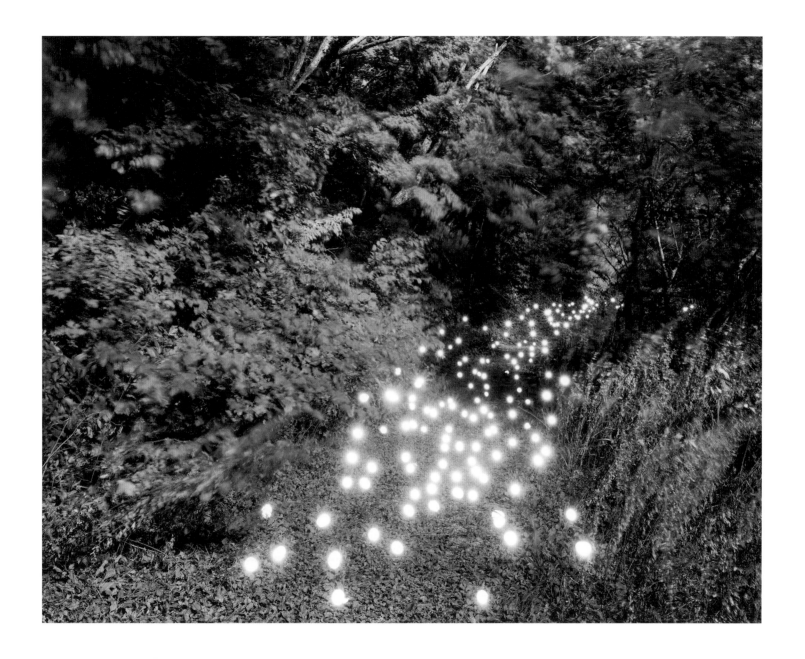

8

#349 Kashimagawa

1998

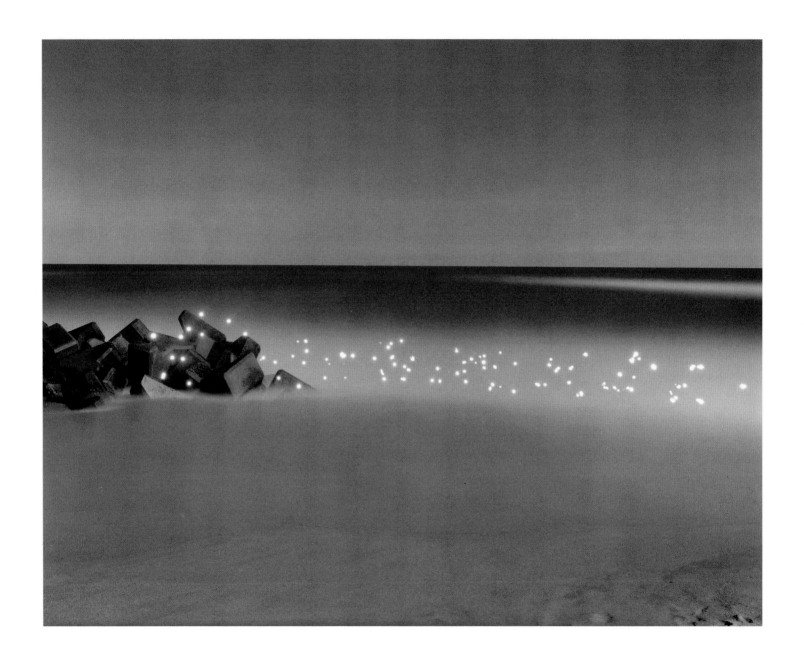

9

#323 Yotsukura and *#324 Yotsukura* (diptych)

1996

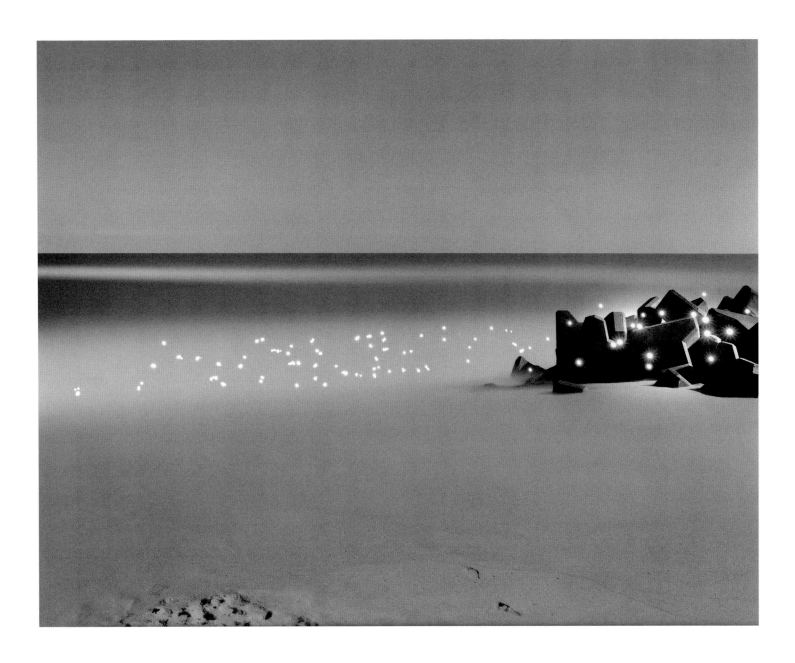

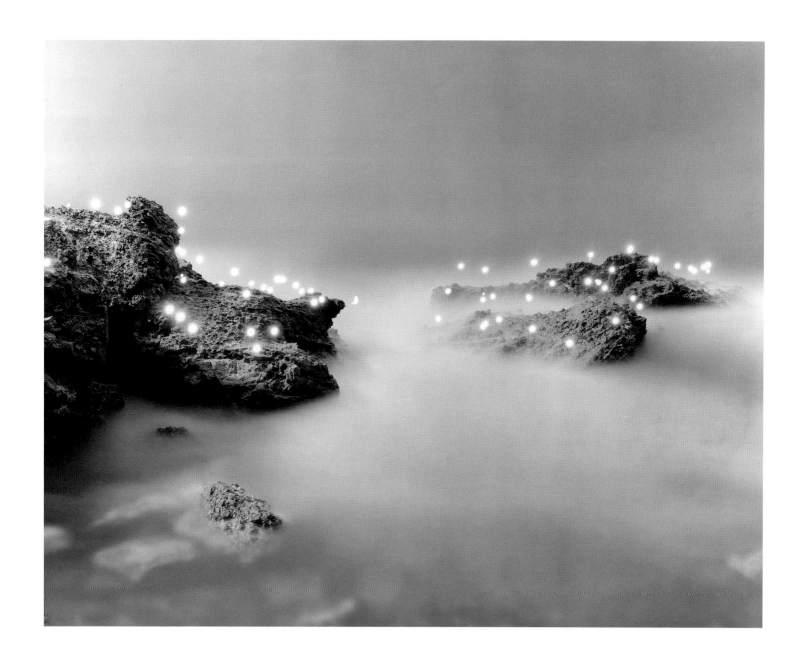

10

#388 Yura

1999

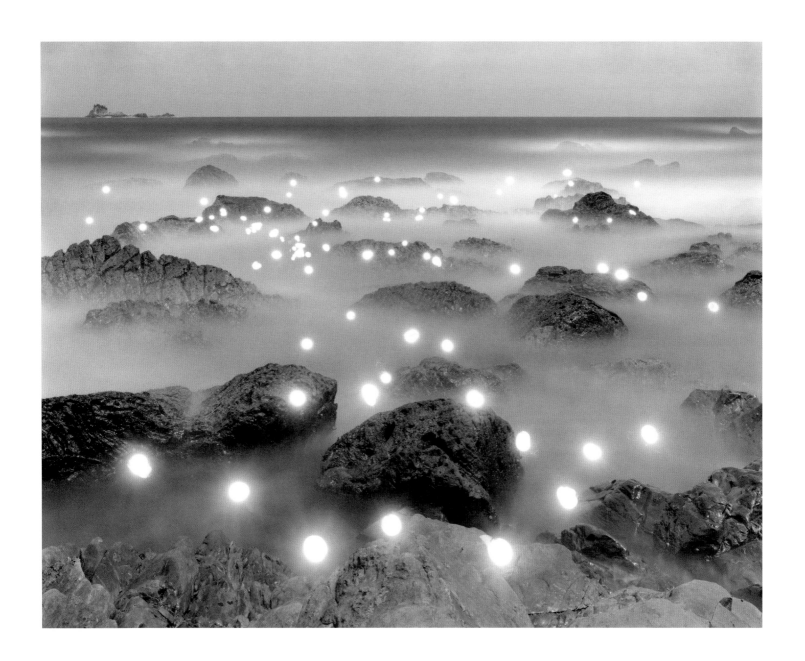

11

#330 Taiji

1998

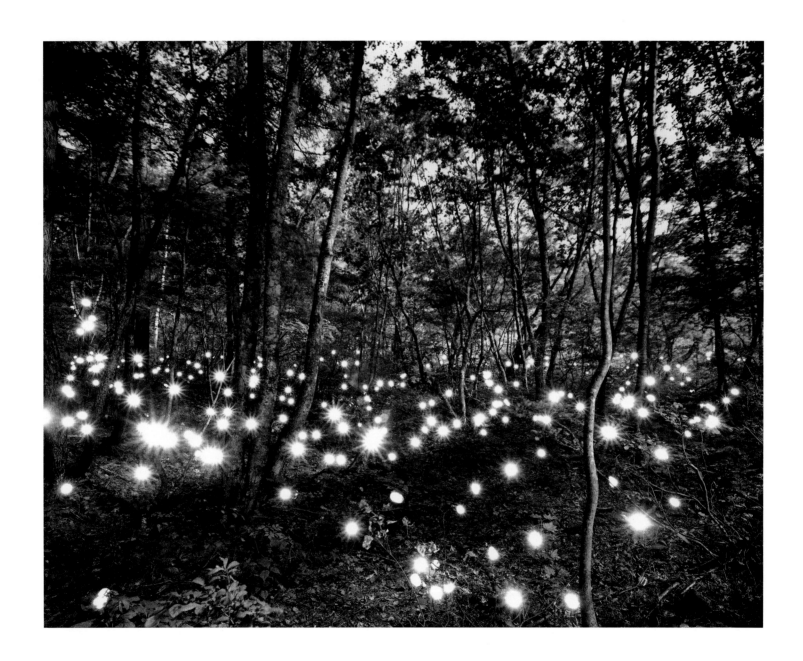

12

#352 Kashimagawa

1998

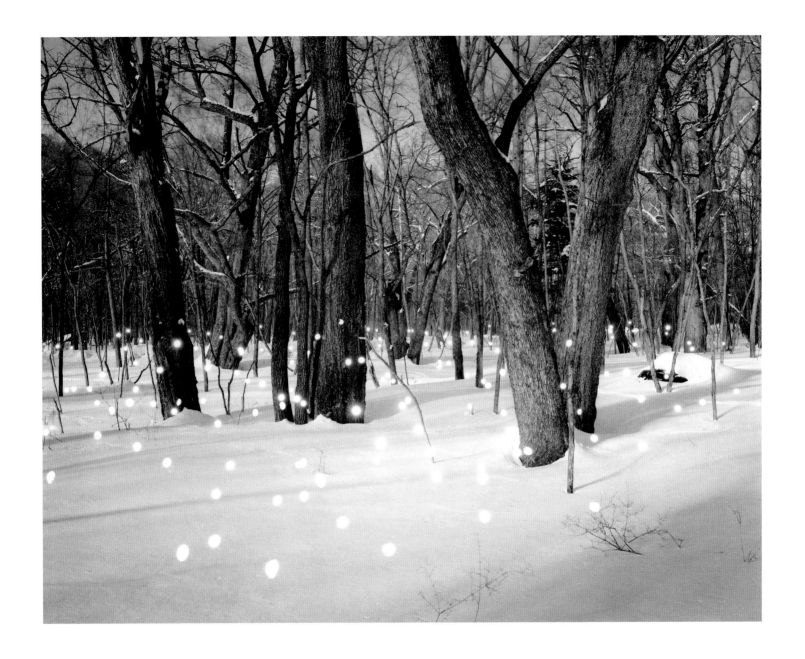

13

Nikko 5

2001

AN INTERVIEW WITH TOKIHIRO SATO

Elizabeth Siegel corresponded with Tokihiro Sato in November 2004.

Elizabeth Siegel: Can you remember the first photograph you saw or were aware of?

Tokihiro Sato: My father was fond of photography. The first photograph I recall seeing was one of me as a baby in a washbasin having my first bath.

ES: How did you get started with photography? Can you remember the first picture you made?

TS: I took my first photographs when I was in the fifth grade with a camera I assembled that came with a supplement to a children's science magazine. However, my interest in photography didn't last long. It was not until after I entered the sculpture department of art school that a friend showed me how to use a darkroom, and I started to make my own prints. That's when I began pursuing photography as a hobby. My installations could only be preserved through photographs. It became a way to record my work, which then began to draw closer to the world of photography.

ES: Photography has become such a dominant art medium in Japan. Did the generation of photographers before you influence your thinking and practice, or is your work a departure from them?

TS: At the time, I had no particular interest in or relation to the photographers who have now become famous. My photographs arose from my interest in conceptual and land art. From the 1970s through the 1980s, artists used photography as a medium of expression, and I became interested in those possibilities. These days I am rather more interested in the world of straight photography, which presents an objective and realistic representation.

ES: You have a very unusual method of making photographs. Could you explain the origins of this technique?

TS: Before I expressed myself in photographic works as I do now, I sculpted pieces of iron by repeatedly pounding them with a hammer. The resulting work reflected the relationship between the time I devoted to reforming the metal, and the expressive space I worked in. However, in the midst of this

monotonous activity, I felt a desire to create images of tangible scenes and light. Since the starting point for my work was to deny the depiction or making of concrete things, I was very grateful to photography, which automatically gives solid expression to the world. I conceived of various ideas to document my own existence within my photographs. I began using a flashlight to create forms and leave a record of my activities at night. Shortly after that, I started using a mirror to similar effect during the day.

ES: Could you describe, in detail, the process of making one of your photographs?
TS: When I work in the evening, I set up a tripod with an 8 x 10-inch camera in front of the space I want to record. Then, I define the light image by using a small, battery-operated flashlight of my own design to trace the lines one at a time. In doing so, what is particularly interesting is the gap in perspective that arises when a three-dimensional space becomes a two-dimensional photographic image. Essentially, I create a drawing that functions like a Global Positioning System for the viewer to imagine where I am in the three-dimensional space and how this is depicted in the two-dimensional film.

When I photograph during the day, I use mirrors. With these, I follow nature even more faithfully than when I use a flashlight, by referring to the position of the sun and the condition of the clouds. The sea presents various conditions as fleeting opportunities, such as the height of the waves and the tide level.

Basically, preparations for daytime work are the same as when I use a flashlight, but the only difference from night photography is that I use a filter to prevent overexposure. I use a small, hand-held mirror to direct the sunlight toward the camera while shooting the picture. This is extremely challenging, because if the angle is off by even one degree, the light does not hit its mark. It is particularly difficult to shoot pictures when being rocked by ocean waves; however, this type of physical connection is an essential element of my work.

28

ES: The setting for your photograph #87 *Shibuya* (plate 5) is one of the busiest intersections in Tokyo. How do bystanders react when seeing you make what must seem like a performance?

TS: There is a great difference in the way bystanders react in big-city venues like Shibuya as compared to how they react in the suburbs. When I work in the suburbs, I explain to people what I'm doing (making photographic works of art) while I'm doing it. However, in places like Shibuya where crowds gather, I work with an assistant, and the majority seems to ignore us, as if we're doing something a little strange. Actually, this makes it easier for us to work.

ES: Do you consider yourself a photographer or a sculptor (or neither)? What connections do you see between sculpture and photography—three dimensions and two dimensions—in your work?

TS: Some have called me a photographer, while others have called me a sculptor, but I am not interested in being limited by such terminology. Although I work in the three-dimensional realm, my current style of photographic expression results in two-dimensional representation. The process of making a photograph through my own activity is a highly significant element of my style. In other words, in actually making the photograph (a three-dimensional activity), I exert a lot of effort and sweat in order to achieve an exaggerated representation. The two-dimensional result has a refined clarity in which the essence of the objects is distilled. I think it is important to consider what is not captured in the photograph, as well as what is. I believe it helps stimulate the viewer's imagination to conceive of these three-dimensional renderings as existing within the context of a two-dimensional piece of work.

There are several reasons why I moved from sculpture to photography. I used to make sculptures from iron. My focus was on the relationship between substance and corporeality, rather than on making shapes. I was interested in the process of creating physical entities, although the action of hammering iron rods and welding them together naturally resulted in a finished shape or form. In the late 1980s, I began to make drawings in space using light and to record them using

a long exposure time. With this technique, I felt I was able to create works with much greater life than when I tried to do so with iron. The essential elements of my work now involve capturing light as a sculpted physical substance and using perspective to create gaps in position and to change shapes when converting a three-dimensional space into a two-dimensional surface. I would say that the connection between photography and sculpture is that they both readily express time. For me, the two are connected when I express time through activity.

ES: You show your photographs in several different formats; perhaps the most striking is the large-scale transparency mounted in front of a panel of lights. How did you arrive at this presentation, and why do you choose to show your images this way?
TS: Since I embarked on photographic expression in the middle of my career, I had doubts about photography as a modality. Generally speaking, the biggest problem with photography is not the photoprint paper, but rather, the world of images depicted on it. In fact, I am interested in different aspects of the representation, such as why photographs are square, even though the image projected by a lens is round, and in the paper itself. I wish to show that even though the paper is thin, it is a substance that possesses a thickness perceived as thinness. When I exhibit large works, I present them in such a way that the sides and back of the paper are separated from the wall. In an image printed on ordinary photoprint paper, the spots of light appear white, whereas transparencies allow actual light to permeate the spots.

ES: You have described these pictures as "breath-graphs" or "photo-respiration." They show life and lived experience; or, as you have said, they remind us that "respiration means 'to live.'" Can you discuss the importance of the human presence in your work?
TS: The actual significance of the title "breath-graphs" is borne out in my own activity when I produce works of art. There is a direct connection between my breath and the act of tracing out the light. This has the same significance as in monotonous activities such as long distance running or swimming, when one's focus is only on breathing. This is why I chose such a title.

ES: Most photographers remain behind the camera, but you enter the space in front of it. Is this a self-portrait in any way?

TS: Technically, I suppose you could call it a self-portrait. However, I do not want to depict myself. Instead, I want to express universal human existence by the fact that I myself do not appear in any of my photographs.

ES: In your pictures, things present before the camera become absent, and new forms seem to materialize. What do you think the process allows us to see that we can't see ordinarily—what does it reveal?

TS: Indeed, absence evokes images suggesting that at least someone or something was there.

ES: The mysterious spots of light hint at a spirit world. Is there a spiritual dimension to your work?

TS: I don't think about my art in a "spiritual" context. However, it is a fact that light evokes such connotations. Also, my own activity involves monotonous repetition such as breathing, which in itself might well be a spiritual world.

ES: You have said you are drawn to certain places—that they give off a "spark" of some sort. Can you talk about the "magnetism" of specific places? How do you select your sites, and how important is a sense of place to you?

TS: I intuitively perceive an aura in some spaces. It may derive from the historical or social import of the place. I select the locations I photograph based on my own sense of their significance.

ES: Can you give an example of why you chose a particular site?

TS: Since we have already discussed #87 Shibuya, I will use that as my example. It is a kind of monument of Japan's rapid bubble-economy expansion, and it is also a pulsating hub of activity in modern Tokyo. It has both vitality and "weight," and at the same time it possesses a peculiar emptiness that reflects the post-bubble economy. In my image, the people disappear and the scene takes on these intangible aspects.

ES: In English the word "photography" is derived from the Greek words for light and writing: literally, "light-writing." In Japanese the word is *shashin*, or "truth-copy." Which term do you think applies more to your work, and why?

TS: From my initial photographs, I have adhered to the concept of "photo" meaning "light." My first title, "breath-graph," substituted "breath" for "photo." Indeed, I recognized photography as a medium for tracing out light.

ES: Do you think there is anything specifically Japanese about your work? Does it connect with other traditionally Japanese art forms (e.g., handscrolls that compress events over time within the same frame) or refer to any particularly Japanese concepts?

TS: I don't think there is anything specifically Japanese about my work, especially when you think of it in relation to Japanese traditional arts or artistic sensibilities. However, I cannot escape the fact that I am Japanese, and it is possible that sometimes certain intrinsic characteristics of this unconsciously appear in my work.

ES: Your photographs are made over a period of an hour or more, unfolding like a movie. We viewers experience them all at once, simultaneously. You have also made a video in which viewers participate in the process of making the picture with you. How do you relate the experience of viewing one of your photographs to that of viewing your video?

TS: My images are exposures that take a long time to execute, and although one can absorb the visual aspect in a single glance, there are further ideas that I wish to convey. It is difficult to imagine the time involved in making a picture. However, the lights serve as markers of the passage of time. When we begin to conceive of this aspect of the photograph, it becomes deeply interesting and extends our understanding of the image. The video that is projected through the back of the transparency captures all of the activity that went into creating the final still photograph. The elapsing of time, the arrangement of the lights, the flickering of the mirror, and my movement enter the viewer's consciousness and add new insight into the process of the work. I think it helps one expand his or her awareness into the meaning of these reflected lights.

ES: You have been creating public camera-obscura sculpture, and in your own house you have integrated lenses in the walls. Why? Is this a new direction for you?

TS: My attempt to imagine light as a physical substance resulted in my photographic prints. My camera-obscura sculptures are a more tangible visualization of light. Photographic expression took me out of my studio and into the city streets. The act of taking pictures brought me into contact with lots of people, and the camera obscura became an interface for my desire to pursue social contact. I became interested in taking a camera into the streets and presenting it in a mysterious way, so as to stimulate people, and to give them an experience that transports them to a place somewhat removed from their daily life. Japanese society differs from Western societies in that it is culturally flat. What I mean by this is that after World War II, the various strata of Japanese society became culturally homogenous. As a result, there is resistance to contemporary art. That's why I think there are more possibilities for activity in the city than in displaying works of art in the somewhat static environment of a museum or gallery. Since the invention of the camera in the nineteenth century, the camera obscura is no longer popular. However, camera-obscura images have a kind of purity because they arise from such a simple apparatus; they create a mysterious visualization of light. I hope to have an even greater number of people experience the modern mobile camera obscura.

ES: What is next for you?

TS: As I continue to produce photographic works, I also want to consider a variety of other possibilities for artistic activity. I have recently embarked upon what I call the "sightseeing-bus camera project." A number of lenses are mounted on both sides of a bus, and the resulting images are projected on both sides of a large screen that runs down the center of the bus. Passengers can watch the screen while the bus is in motion. The images projected from the multiple lenses, plus the effects of gravity felt by the body as the bus moves, combine to depict a unique world that both adults and children, people interested or not interested in art, can derive something from experiencing.

Translation by John F. Bukacek

EXHIBITION HISTORY

BIBLIOGRAPHY

CHECKLIST

TOKIHIRO SATO

Born in 1957, Sakata, Yamagata Prefecture, Japan

BFA in sculpture, Tokyo National University of Fine Arts and Music, 1981

MFA in sculpture, Tokyo National University of Fine Arts and Music, 1983

ONE-PERSON EXHIBITIONS

2005 Art Institute of Chicago, *Photo-Respiration: Tokihiro*
 Sato Photographs
 San Francisco, Haines Gallery

2004 Urawa, Museum of Modern Art Saitama
 Yamaguchi Center for Arts and Media,
 Camera-Obscura Project

2003 Cleveland Museum of Art, *Points of Light*
 New York, Leslie Tonkonow Artworks + Projects,
 New Photographic Works

2002 Hamada Children's Museum of Art

2001 Tokyo, Gallery Gan

2000 New York, Leslie Tonkonow Artworks + Projects,
 Recent Photographic Works

1999 Sakata City Museum of Art
 Tokyo, Gallery Gan

1998 New York, Leslie Tonkonow Artworks + Projects,
 Recent Photographic Works

1997 Tokyo, Gallery Gan

1996 Tokyo, Gallery Gan
 Tokyo, Gallery Natsuka

1995 Tokyo, Gallery Lunami
 Tokyo, Gallery Nikko

1993 Tokyo, Gallery Surge
 Agen, France, Musée des Beaux-Arts, *Jacobins*
 Tokyo, Spiral Garden

1992 Tokyo, Gallery Hosomi
 Tokyo, Gallery Moris
 Nagano, Gallery Valentine
 Sapporo, Gallery Temporary Space #022

1991 Tokyo, Gallery Lunami
 Tokyo, Gallery Surge
 Tokyo, E'Space

1989 Tokyo, Gallery Lunami

1988 Tokyo, Gallery Lunami

1987 Tokyo, Gallery Maki

1986 Tokyo, Gallery Parergon II

1984 Tokyo, Gallery Tamura

1983 Tokyo, Gallery Lunami

1982 Tokyo, Gallery Tokiwa
 Tokyo National University of Fine Arts and Music,
 University Hall Gallery
 Tokyo, G Art Gallery

SELECTED GROUP EXHIBITIONS

2004 San Francisco, Haines Gallery, *Temporalscape*

2003 Hiroshima City University, *The Imaginary City
"Metamorphosis" Hiroshima*

Museum of Fine Arts Houston; Cleveland Museum of
Art, *The History of Japanese Photography*

2002 Philadelphia, SEI Rosenwald-Wolf Gallery, University of
the Arts, *Staging Reality: Photography from the
West Collection*

Toronto, Museum of Contemporary Canadian Art;
Montreal, Saidye Bronfman Centre for the Arts,
Regarding Landscape

Oita Art Museum, *Cyclical Art Site: Contemporary Art
Exhibition in Oita 2002*

2001 New York, Leslie Tonkonow Artworks + Projects, *Ellipsis*

Washington, Bellevue Art Museum, *Luminous*

Tokyo, NTT InterCommunication Center, *Techno-
Landscape: Toward Newer World Textures*

Utsunomiya Museum of Art, *VIBRATION: Expressive
Power of Sculpture*

Seattle, G. Gibson Gallery

2000 New York, Comité Colbert, *City Lights Artwalk*

New York, Leslie Tonkonow Artworks + Projects

Annandale-on-Hudson, New York, Bard College Center
for Curatorial Studies, *On Site: Contemporary
Photography of Place*

Niigata, *Echigo-Tsumari Art Triennial 2000*

1999 Summit, New Jersey Center for the Visual Arts,
Full Exposure

New York, Robert Mann Gallery, *Blind Spot 12*

Vermont, Middlebury College Museum of Art: *The Big
Picture: Large-Format Photography*

Urawa, Museum of Modern Art Saitama,
Breathing Landscapes

Dhaka, Bangladesh, *9th Asian Art Biennial*

1998 Tokyo, Itabashi Art Museum, *Attack/Damage*

Rio de Janeiro and five other cities in Brazil, *Japan-Brazil
International Tour Exhibition 98/99*

New York, Hunter College, Bertha and Karl Leubsdorf
Art Gallery, *Catherine Opie, Richard Rothman, and
Tokihiro Sato*

1997 Honolulu, Contemporary Art Museum, *Photography and
Beyond in Japan: Space, Time and Memory*

6th Havana Biennial

Shibukawa, Hara Museum ARC, *Ways of (Re)Production*

1996 Los Angeles County Museum of Art; Washington, D.C.,
Corcoran Gallery of Art; Denver Art Museum,
*Photography and Beyond in Japan: Space, Time
and Memory*

Berlin, Neue Gesellschaft für Bildende Kunst; Sweden,
Göteborg Kunsthalle; Budapest, Müscarnok Palace
of Exhibitions, *Liquid Crystal Futures*

Saitama, Saito Memorial Kawaguchi Museum of
Contemporary Art, *Enokura and 33 Artists*

Tokyo, Former Schoolhouse of Akasaka Elementary
School, *Twelve Environments—Japan-Netherlands
Contemporary Art Exchange Exhibition*

Tokyo, Dojunkai-Daikanyama Apartment, *Playback
and Memory*

Iwaki City Art Museum, *Gazing into the Light—
Tokihiro Sato and Shigenobu Yoshida*

1995 Mexico City, Museo de Arte Contemporaneo
Internacional Rufino Tamayo; Vancouver Art Gallery,
*Photography and Beyond in Japan: Space, Time
and Memory*

Hiroshima City Museum of Contemporary Art, *After
Hiroshima—Message from Contemporary Art II*

Hiroshima, *Haizuka Earthworks Project*

Holland, Het Aporo House, *NowHere*

Yamagata Museum of Art, *Nostalgia for Future—
Contemporary Art of Yamagata*

Omiya, *Open—Air Exhibition—Passage of the Wind*

Tokyo, Spiral Garden, *Liquid Crystal Futures*

1994 Tokyo, Hara Museum of Contemporary Art, *Photography and Beyond in Japan: Space, Time and Memory*

Edinburgh, Fruitmarket Gallery; Copenhagen, Charlottenborg, *Liquid Crystal Futures*

Urawa, Museum of Modern Art Saitama, *Visualization in the End of the 20th Century*

Otsu, Museum of Modern Art Shiga, *Time/Art: 'Time' Is Expressed in 20th Century Art*

1993 Tokyo, Sagacho Exhibit Space, *00 Collaboration*

Brisbane, Queensland Art Gallery, *1st Asia-Pacific Triennial of Contemporary Art*

1992 Yokohama Galleria Bellini Hill, *1st Transart Annual Painting/Crossing*

Tokyo, Gallery Lunami, *Okabe e Sato a Roma 1991*

Seoul, Walker Hill Art Center, *Japanese Contemporary Photographs*

1991 Tokyo, Machida City Museum of Graphic Arts, *Compound of the Maniera*

Rome, Museo di Roma Palazzo Braschi, *Simultaneità*

Tokyo National University of Fine Arts and Music, *Photographic Narration II*

Urawa, Museum of Modern Art Saitama, *Line in Contemporary Art—The Destination of Eyes and Hands*

Sapporo, Gallery Temporary Space #012, *Okabe e Sato a Roma 1991*

Tokyo, Ohara Center, *10th Parallelism in Art Exhibition*

London, Photographers' Gallery, *Make-Believe*

Wroclaw, Poland, *New Space of Photography*

Tokyo, Parco Gallery, *20 Promising Photographers Vol. 2*

Tokyo, Gallery Lunami, *Australia-Japan Joint Exhibition*

Tokyo, Gallery Hosomi, *Hiroshi Yamazaki-Tokihiro Sato: Two-Man Exhibition*

1990 Tokyo Metropolitan Art Museum, *18th International Art Exhibition Japan*

Higashikawa International Photography Festival

Tokyo Metropolitan Museum of Photography; Paris, Pavillon des Arts, *Japanese Contemporary Exhibition*

South Korea, *5th Pusan Biennial*

Utsunomiya, Tochigi Prefectural Museum of Fine Art, *The Imprinted Ideas*

1989 Tokyo Metropolitan Art Museum, *Japan Professional Photographer, Society Exhibition*

Tokyo, Gallery Lunami, *Lunami Selection '89*

Yamanashi, *Summer Festival '89 in Hakushu ('90, '91, '92)*

Hamamatsu, Entetsu Department Store, *Window of Marginal Arts*

Tokyo, Gallery Surge, *Because*

Tokyo, Heineken Village, *The 151st Year of Photography*

1988 Tokyo National University of Fine Arts and Music, *Photographic Narration*

Tokyo, Tama Art University, *15 Contemporary Photographic Expressions*

1981 Tokyo Metropolitan Art Museum, *15th Contemporary Art Exhibition of Japan*

AWARDS

1994 The Japanese Government Overseas Study Program

1993 Mercedes-Benz in Japan Art Scholarship
(Grand Prix Award)

SELECTED BIBLIOGRAPHY

Aletti, Vince. 2000. "Tokihiro Sato." *Village Voice,* July 25.

Costa, Eduardo. 1999. "Report from Havana: The Installation Biennial." *Art in America* 86, 3 (Mar.), pp. 50–57.

Fouser, Robert J. 1999. "In Praise of Mad Shadows: The Photography of Tokihiro Sato." *Art AsiaPacific* 21, pp. 44–49.

Glueck, Grace. 1998. "Tokihiro Sato." *New York Times,* Mar. 13, p. E35.

Hammond, Anna. 2000. "Tokihiro Sato at Leslie Tonkonow." *Art in America* 88, 11 (Nov.), p. 164.

Koplos, Janet. 1997. "Through a Japanese Viewfinder." *Art in America* 85, 3 (Mar.), pp. 84–92.

Kuspit, Donald. 2003. "Three Photographers: Luis Mallo, Jean Luc Mylayne, Tokihiro Sato." *Art New England* 24, 6 (Oct./Nov.), pp. 8–9.

Nagoya, Satoru. 1999. "Tokihiro Sato: Gan." *Flash Art* 32, 206 (May/June), p. 123.

Nahas, Dominique. 1998. "Tokihiro Sato at Leslie Tonkonow." *Review* (Mar. 15), p. 27.

O'Toole, Erin. 2004. "Curators as Collectors." *Camera Arts* 24, 5 (Aug./Sept.), pp. 30–35.

Pollack, Barbara. 1998. "Tokihiro, Leslie Tonkonow." *Artnews* 97, 6 (June), p. 126.

Sato, Tokihiro, Enari Tsuneo, and Tsuchida Hiromi. 1997. *Photo-Respiration.* Nikon Salon Books.

Sato, Tokihiro. 1997. *Photo-Respiration from Havana.* Exh. cat. Gallery Gan.

Stearns, Robert, et al. 1995. *Photography and Beyond in Japan: Space, Time and Memory.* Exh. cat. Hara Museum of Contemporary Art/Harry N. Abrams, Inc., Publishers.

Tarzan Ament, Deloris. 2000. "Light as Image." In *Luminous.* Exh. cat. Bellevue Art Museum, pp. 43–47.

Tucker, Anne Wilkes, Dana Friis-Hansen, Kaneko Ryuichi, Takeba Joe, and Kinoshita Naoyuki. 2003. *The History of Japanese Photography.* Exh. cat. Museum of Fine Arts Houston/Yale University Press.

CHECKLIST

All works by Tokihiro Sato
Japanese, born 1957
All gelatin silver transparency over light panel
Unless otherwise noted, all 90 x 113 cm (35 1/2 x 44 1/2 in.)

1. *#22*, 1988
 113 x 90 cm (44 1/2 x 35 1/2 in.)
 Courtesy Leslie Tonkonow Artworks + Projects, New York

2. *#370 Saitamakinbi*, 1999
 113 x 90 cm (44 1/2 x 35 1/2 in.)
 Courtesy Leslie Tonkonow Artworks + Projects, New York

3. *#278 Koto-ku Aomi*, 1996
 Courtesy Leslie Tonkonow Artworks + Projects, New York

4. *#267 Minato-ku Daiba*, 1996
 Courtesy Leslie Tonkonow Artworks + Projects, New York

5. *#87 Shibuya*, 1990
 90.4 x 113.6 cm (35 5/8 x 44 3/4 in.)
 Courtesy Leslie Tonkonow Artworks + Projects, New York

6. *#166 Akihabara*, 1992
 Courtesy Leslie Tonkonow Artworks + Projects, New York

7. *#161 Shimizusawa*, 1992
 Courtesy Leslie Tonkonow Artworks + Projects, New York

8. *#349 Kashimagawa*, 1998
 Courtesy Leslie Tonkonow Artworks + Projects, New York

9. *#323 Yotsukura* and *#324 Yotsukura* (diptych), 1996
 Courtesy Leslie Tonkonow Artworks + Projects, New York

10. *#388 Yura*, 1999
 Private collection, New York

11. *#330 Taiji*, 1998
 Courtesy Leslie Tonkonow Artworks + Projects, New York

12. *#352 Kashimagawa*, 1998
 The Art Institute of Chicago, restricted gift of David C.
 and Sarajean Ruttenberg, 2004.251

13. *Nikko 5*, 2001
 89.7 x 113.2 cm (35 1/4 x 44 5/8 in.)
 Private collection, New York